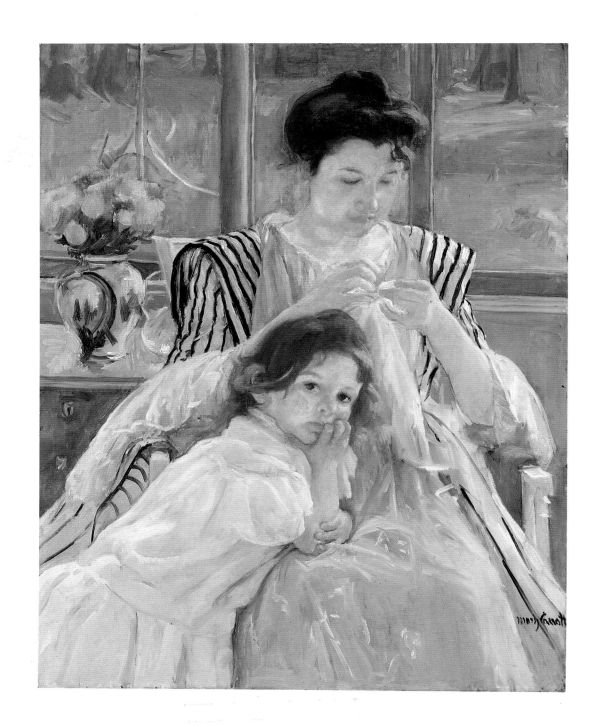

WHAT MAKES A CASSATT A CASSATT?

Richard Mühlberger

The Metropolitan Museum of Art
Viking

NEW YORK

VIKING
First published in 1994 by The Metropolitan Museum of Art, New York, and Viking, a division of Penguin Books USA Inc., 375 Hudson Street, New York, New York 10014, U.S.A. and Penguin Books Canada Ltd., 10 Alcorn Avenue, Toronto, Ontario, Canada M4V 3B2.

Produced by the Department of Special Publications, The Metropolitan Museum of Art.
Series Editor: Mary Beth Brewer
Production: Elizabeth Stoneman
Front Cover Design: Marleen Adlerblum
Design: Nai Y. Chang
Printing and Binding: A. Mondadori, Verona, Italy

Library of Congress Cataloging-in-Publication Data
Mühlberger, Richard. What makes a Cassatt a Cassatt?/Richard Mühlberger. p. cm.
ISBN 0-670-85742-4 (Viking)
ISBN 087099-721-1 (MMA)
1. Cassatt, Mary, 1844–1926—Criticism and interpretation—Juvenile literature. 2. Painting, American—Juvenile literature. 3. Impressionism (Art)—Juvenile literature. [1. Cassatt, Mary, 1844–1926. 2. Painting, American. 3. Art appreciation.] I. Title.
ND237.C3M85 1994 759.13—dc20 94-18109 CIP AC

10 9 8 7 6 5 4 3 2 1

ILLUSTRATIONS

Unless otherwise noted, all works are by Mary Cassatt and in The Metropolitan Museum of Art.

Pages 1 and 2: *Young Mother Sewing*, oil on canvas, 36 3/8 x 29 in., ca. 1900, H. O. Havemeyer Collection, Bequest of Mrs. H. O. Havemeyer, 1929, 29.100.48.

Page 6: *Portrait of the Artist*, gouache on wove paper laid down to buff-colored wood-pulp paper, 23 5/8 x 16 5/16 in., 1878, Bequest of Edith H. Proskauer, 1975, 1975.319.1.

Page 8: Gihon and Rixon, photographers, *Pennsylvania Academy Modeling Class*, 1862, albumen photograph with hand coloring, 7 3/8 x 5 3/8 in., Courtesy of the Pennsylvania Academy of the Fine Arts, Philadelphia. Archives.

Page 9: Édouard Manet, *The Spanish Singer*, oil on canvas, 58 x 45 in., 1860, Gift of William Church Osborn, 1949, 49.58.2.

Page 9: Edgar Degas, *At the Louvre: Mary Cassatt in the Etruscan Gallery*, softground etching, drypoint, aquatint, and etching, 10 1/2 x 9 1/8 in., 1879–80, Rogers Fund, 1919, 19.29.2.

Page 10: *Offering the Panale to the Bullfighter*, oil on canvas, 39 5/8 x 33 1/2 in., 1873, Sterling and Francine Clark Art Institute, Williamstown, Massachusetts.

Page 11: Diego Velazquez, *The Waterseller of Seville*, oil on canvas, 42 x 31 7/8 in., Apsley House, London; photograph, Bridgeman/Art Resource, New York.

Page 13: *Little Girl in a Blue Armchair*, oil on canvas, 35 1/2 x 51 1/8 in., 1878, Collection of Mr. and Mrs. Paul Mellon, © 1994 National Gallery of Art, Washington.

Page 15: Suzuki Harunobu (1725–1770), *A Man and a Woman Playing Go*, color woodblock print, 11 1/8 x 8 1/8 in., Henry L. Phillips Collection, Bequest of Henry L. Phillips, 1939, JP 2773.

Page 15: Utagawa Hiroshige (1797–1858), *Kinryūzan Temple, Asakusa*, from the series *One Hundred Famous Views of Edo*, color woodblock print, 13 3/8 x 8 3/4 in., 1858, Gift of Estate of Samuel Isham, 1914, JP 1025.

Page 17: *At the Opéra*, oil on canvas, 31 1/2 x 25 1/2 in., 1879, The Hayden Collection, Courtesy, Museum of Fine Arts, Boston.

Page 18: *Lydia Crocheting in the Garden at Marly*, oil on canvas, 26 x 37 in., 1880, Gift of Mrs. Gardner Cassatt, 1965, 65.184.

Page 20: *The Cup of Tea*, oil on canvas, 36 3/8 x 25 3/4 in., From the Collection of James Stillman, Gift of Dr. Ernest G. Stillman, 1922, 22.16.17.

Page 21: *Lady at the Tea Table*, oil on canvas, 29 x 24 in., 1883–85, Gift of the artist, 1923, 23.101.

Page 22: *Five O'Clock Tea*, oil on canvas, 25 1/2 x 36 1/2 in., M. Theresa B. Hopkins Fund, Courtesy, Museum of Fine Arts, Boston.

Page 27: *Reading Le Figaro*, oil on canvas, 39 1/2 x 32 in., 1878, private collection, Washington, D.C.

Page 28: *Children Playing on the Beach*, oil on canvas, 38 3/8 x 29 1/4 in., 1884, Ailsa Mellon Bruce Collection, © 1994 National Gallery of Art, Washington.

Page 29: Claude Monet, *Regatta at Sainte-Adresse*, oil on canvas, 29 5/8 x 40 in., 1867, Bequest of William Church Osborn, 1951, 51.30.4.

Page 30: *The Letter*, drypoint and aquatint, printed in colors, fourth state, 13 5/8 x 8 15/16 in., 1890–91, Gift of Paul J. Sachs, 1916, 16.2.9.

Page 32: Kitagawa Utamaro (1754–1806), *Faces of Beauties: Hinazuru of the Keizetsuro*, woodblock print, 15 1/2 x 10 3/8 in., ca. 1796, Clarence Buckingham Collection, 1925.3047; photograph © 1994, The Art Institute of Chicago. All Rights Reserved.

Page 33: Kitagawa Utamaro (1754–1806), *Midnight: Mother and Sleepy Child*, from the series *Customs of Women in the Twelve Hours*, color woodblock print, 14 3/8 x 9 5/8 in., Rogers Fund, 1922, JP 1278.

Page 33: *The Bath*, drypoint, softground etching, and aquatint printed in colors, seventeenth state, 11 5/8 x 9 3/4 in., 1890–91, Gift of Paul J. Sachs, 1916, 16.2.7.

Page 34: *Baby Reaching for an Apple*, oil on canvas, 39 1/2 x 25 3/4 in., 1893, Virginia Museum of Fine Arts, Richmond. Museum purchase with funds provided by an anonymous donor.

Page 35: *Gathering Fruit*, drypoint, softground etching, and aquatint printed in colors, eleventh state, 16 3/4 x 11 11/16 in., ca. 1893, Rogers Fund, 1918, 18.33.4.

Page 36: *In the Omnibus*, drypoint and aquatint printed in colors, seventh state, 14 5/16 x 10 1/2 in., 1890–91, Gift of Paul J. Sachs, 1916, 16.2.4.

Page 37: *Mother Feeding Her Child*, pastel on paper, 25 1/2 x 32 in., 1898, From the Collection of James Stillman, Gift of Dr. Ernest G. Stillman, 1922, 22.16.22.

Page 37: *Young Mother Sewing*, oil on canvas, 36 3/8 x 29 in., ca. 1900, H. O. Havemeyer Collection, Bequest of Mrs. H. O. Havemeyer, 1929, 29.100.48.

Pages 38–39: *The Boating Party*, oil on canvas, 35 7/16 x 46 1/8 in., 1893–94, Chester Dale Collection, © 1994 National Gallery of Art, Washington.

Page 40: Édouard Manet, *Boating*, oil on canvas, 38 1/4 x 51 1/4 in., 1874, H. O. Havemeyer Collection, Bequest of Mrs. H. O. Havemeyer, 1929, 29.100.115.

Page 41: *Feeding the Ducks*, drypoint, softground etching, and aquatint printed in colors, fourth state, 11 11/16 x 15 3/4 in., ca. 1895, H. O. Havemeyer Collection, Bequest of Mrs. H. O. Havemeyer, 1929, 29.107.100.

Page 42: *Breakfast in Bed*, oil on canvas, 25 5/8 x 29 in., The Virginia Steele Scott Collection, Henry E. Huntington Library and Art Gallery, San Marino, California.

Page 45: *Mother and Child*, oil on canvas, 36 1/4 x 29 in., ca. 1905, Chester Dale Collection, © 1994 National Gallery of Art, Washington.

Page 46: *Mother and Child (The Oval Mirror)*, oil on canvas, 32 1/8 x 25 7/8 in., ca. 1899, H. O. Havemeyer Collection, Bequest of Mrs. H. O. Havemeyer, 1929, 29.100.47.

Page 47: Baroni and Gardelli, photographers, *Mary Cassatt*, carte de viste, albumen print, ca. 1872, Courtesy of the Pennsylvania Academy of the Fine Arts, Philadelphia. Archives.

Page 49: *The Bath*, oil on canvas, 39 1/2 x 26 in., 1891–92, Robert A. Waller Fund, 1910.2; photograph © 1994 The Art Institute of Chicago. All Rights Reserved.

CONTENTS

Portrait of the Artist

Meet Mary Cassatt

Although she lived most of her life in France, Mary Cassatt was an American. Edgar Degas and other French Impressionists accepted her as one of their own, and she enjoyed fame and success in Europe. In 1895, at the height of her career, she sent her best works to New York City for a public exhibition. When word reached her in France that few people had come to see her paintings, she confessed to a friend, "I am very much disappointed that my compatriots have so little liking for any of my work." Today, however, she is among the most popular of American artists in her native country, and is acclaimed as a pioneer among women artists.

Cassatt was born on May 22, 1844, in Allegheny City, Pennsylvania, which is now part of Pittsburgh. When Mary was five, her family moved to Philadelphia, which she always considered her American home base. Mr. and Mrs. Cassatt revered French culture, and they wanted their children to experience it firsthand. When Mary was seven years old, her parents set out by ship for Europe with their four children. Mary's brother Alexander studied engineering at a technical school in Germany, and during their four-year stay abroad, the other children attended schools there and in France. This was also a period of convalescence for another brother, Robbie, who finally died in 1855. Within months of his death, the Cassatts returned to America in mourning.

In Europe, Cassatt learned to speak both French and German, and she began her acquaintance with the great art of the past. She decided that she wanted to be an artist, despite her father's objections. By the time she was sixteen years old, her father had relented. Mary enrolled in the Pennsylvania Academy of the Fine Arts in the fall of 1860.

A Traditional Education
The Academy had been established in 1805, and

it offered the kind of training typical of European art schools. During her first year there, Mary learned to draw by copying plaster casts of statues from ancient Greece and Rome and from Renaissance Italy, which were considered the highest examples of beauty. Next, she entered life drawing classes. There, with models to work from, she learned how to depict the human form. She also studied anatomy. Finally she was allowed to take up brushes to copy paintings from the Academy's collection.

In Cassatt's day, serious art students eventually had to study in Europe, where they could see the collections of painting and sculpture by master artists. After years of work in America, Cassatt yearned for such contact, and she went to Paris. The French Academy did not enroll female students, but she took private lessons and copied masterpieces in museums and galleries. She also traveled in the French countryside and to Italy to pursue her studies.

Cassatt's training in copying the works of old masters shaped her art. Ancient sculpture and Renaissance paintings feature people, as do almost all of her works. Most of her Impressionist contemporaries preferred to paint landscapes or still lifes, subjects that allowed them to capture in paint fleeting effects of light. Cassatt was always more interested in capturing subtle relationships between people.

Her Career Begins

By the early 1870s, Cassatt not only copied old works, but also created original compositions that were accepted by the Paris Salon, the city's great official art exhibition. Her professional career had begun.

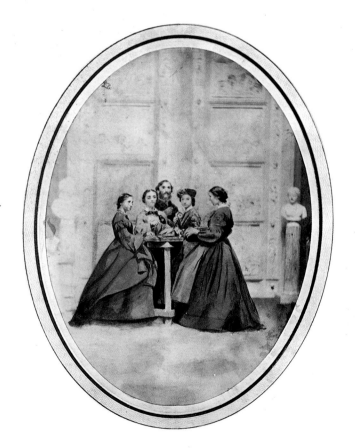

PENNSYLVANIA ACADEMY MODELING CLASS

Mary Cassatt and her classmates are pictured here making a cast of a man's hand. Later they will draw it to increase their understanding of human anatomy.

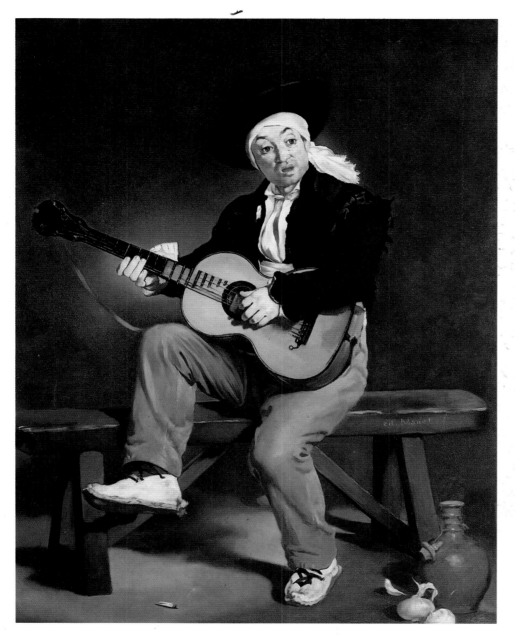

Edgar Degas
AT THE LOUVRE: MARY CASSATT
IN THE ETRUSCAN GALLERY

Edgar Degas, an artist who was Cassatt's friend and mentor, made this print that shows her studying the ancient sculpture in the Louvre, the great museum of Paris.

Édouard Manet
THE SPANISH SINGER

Cassatt's first painting to be selected by the Paris Salon was inspired by the French artist Édouard Manet's paintings of figures in Spanish costume. Before long, Cassatt traveled to Spain to learn directly from Spanish paintings, which were a great source of inspiration for many modern artists.

Offering the Panale to the Bullfighter

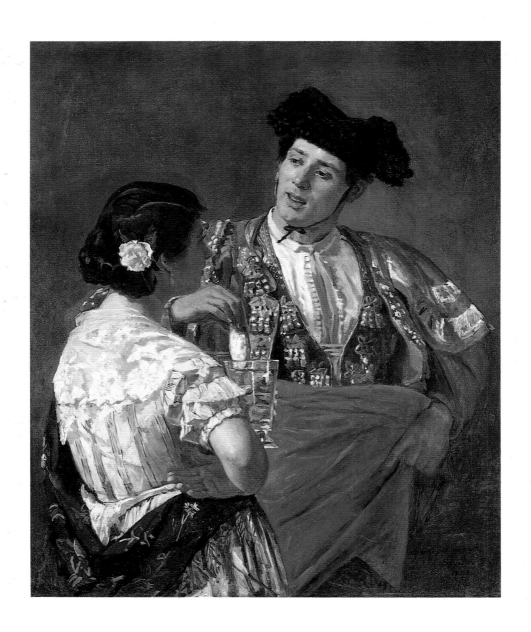

In 1872, Cassatt traveled to Spain, first visiting the great museums in Madrid, and then taking a studio in Seville. While she was there, she became acquainted with the work of Diego Velázquez, the great Spanish master of the seventeenth century. He painted genre pictures, or scenes of everyday life. This work by Cassatt is her version of such a painting.

The work of another great Spanish artist, Francisco Goya, inspired her to paint quickly, with broad, loose strokes. Goya was one of the first artists to abandon the old way of applying a number of layers of paint to create colors. Instead, he used a single application of the color he needed to make the picture seem fresh and spontaneous. This method was favored by young French painters like Édouard Manet. *Au premier coup* (at the first stroke) is the term they used to describe it.

To focus attention on the conversation taking place between her subjects, Cassatt eliminated all background details. The young woman leans backward, casually resting one hand on her hip. Her elbow boldly juts out, bringing the viewer into her space. The bullfighter tilts his head and gazes attentively at his companion as he dips his biscuit into the panale, the sweet drink the girl offers him. Although Cassatt was just twenty-eight years old when she made this work, her lifelong interest in capturing human relationships is already apparent. *Offering the Panale to the Bullfighter* was exhibited at the prestigious Paris Salon of 1873.

The young artist continued traveling, going to Antwerp and Rome to view great works of art. By 1875 she settled in France, which would be her home for the rest of her life.

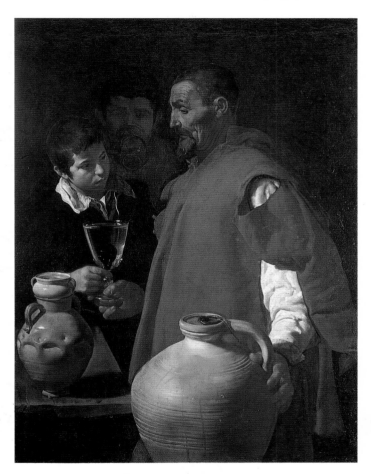

Diego Velázquez
THE WATERSELLER OF SEVILLE

Cassatt's painting was inspired by works such as this one by the great seventeeth-century Spanish artist, Diego Velázquez. She learned from him how to show everyday scenes in a natural way.

Little Girl in a Blue Armchair

The artist has positioned herself very close to this strange interior. She pictures four fat blue chairs, two on either side of the painting, and each cut off by the frame of the canvas. A restless girl squirms on one chair; a little dog sleeps on another. The right side of the painting contains more than the left side. More is shown of the chairs on the right, and the girl's pink skin and disheveled white dress also add visual weight to that area of the painting. Cassatt made the floor between the girl and the dog into an interesting flat shape, balancing the composition. The whole picture is not symmetrical, but it has equilibrium.

Topsy-Turvy Contrasts

How different this painting is from *Offering the Panale to the Bullfighter,* painted just five years before! Instead of the deep, dark colors of the Spanish-style picture, Cassatt's palette has become clear and bright. Instead of the straightforward composition of the earlier painting, the artist here delights in topsy-turvy contrasts. The uptilted floor and viewpoint from above make it look as if the big blue chairs are propelling themselves across the canvas!

Cassatt stated that the biggest influence on her work was Edgar Degas, both the man and his art. Degas was ten years older than Cassatt, and Cassatt was still looking for instruction when she first saw his pastels in an art dealer's window in 1875. She remembered, "I used to go and flatten my nose against that window and absorb all I could of his art. It changed my life. I saw art then as I wanted to see it." She wrote about *Little Girl in a Blue Armchair,* "Degas advised me on the background and he even worked on it." The way the paint is scrubbed on to achieve the look of light coming through window curtains is probably one of his touches. As much as Cassatt admired and learned from Degas, she never slavishly imitated him. One of her unique talents can be seen in this painting: her keen observation of children. Cassatt's little girl is not just a pretty object, for she expresses a boredom and restlessness in her pose and facial expression that a real girl would feel.

Degas was impressed by Cassatt's work, and he invited her to exhibit with the "Independents," a group of artists who challenged the old-fashioned standards of the Salon and were often excluded from its exhibitions. Other artists in this group were Frédéric Bazille, Claude Monet, Berthe Morisot, Camille Pissarro, Pierre-Auguste Renoir, and Alfred Sisley—artists now known as the French Impressionists. Degas showed Cassatt that it was possible to have great respect for old masters, as well as to paint modern

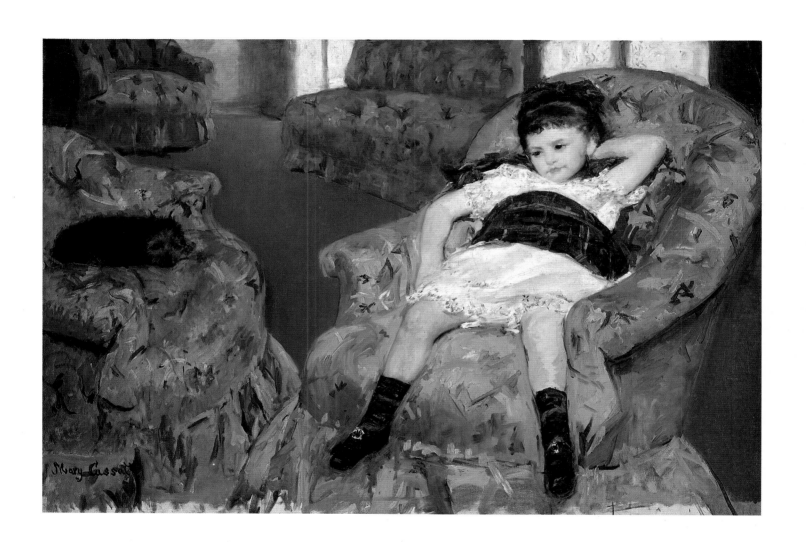

themes in new and exciting ways. At about this time, she began to paint what she knew best—children, family members, and neighbors, the subjects that would make her famous.

Degas shared with Cassatt his great interest in Japanese prints, in which the artists cropped, or cut off, objects at the edges of the composition, making scenes appear candid and realistic. These works also featured tilted perspective, which makes objects in the background clearly visible. The prints were also filled with bright, clear colors. All of these elements are visible in Cassatt's painting: The chairs are cropped by the picture frame, the floor seems to rise up, and the colors are vibrant.

Determined to Be Independent

Although Cassatt felt liberated by the exciting new techniques she learned in Paris, the jury of the 1878 Salon rejected *Little Girl in a Blue Armchair*. But Cassatt was not discouraged. She became more determined than ever.

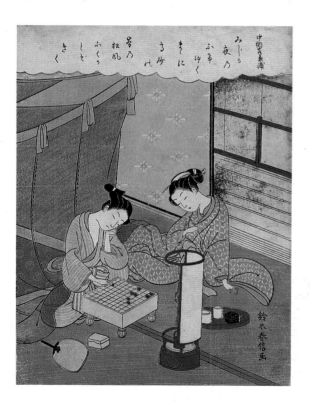

Suzuki Harunobu
A MAN AND WOMAN PLAYING GO

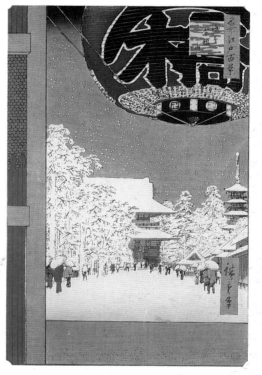

Utagawa Hiroshige
KINRYŪZAN TEMPLE, ASAKUSA

15

At the Opéra

Cassatt focuses on the face and hand of a woman at the Opéra who gazes intently through her glasses. The woman's profile and the angle of her arm, hands, and fan emphasize her steady concentration as she watches the stage. Details of her costume are lost in its rich black color. Cassatt's palette is limited to white, black, and variations of yellow and orange-brown. Manet loved black, and Cassatt might have had his paintings in mind when she decided to dress her woman in stylish black afternoon garb.

A Portrait Tells a Story

In this composition, the woman is the only figure painted in detail. Cassatt daringly constructed the rest of the audience with squiggles, slashes, and splatters of paint to make them seem far away. None of these figures in the distance have eyes or mouths, but their postures explain what they are doing. Some look toward the stage, while the comings and goings of others are indicated by a deft blur of strokes. One gentleman, with his elbow on the railing, leans out past his female companion and aims his opera glasses directly at the woman in black. Will she avert her gaze to discover that she has an admirer? What at first looks like a simple portrait turns out to be a story.

The Paris Opéra was a large theater where orchestras played and ballet and opera companies performed. Portraying its activities, both on and off stage and in the audience, engaged many painters of Cassatt's time. Like Degas, Cassatt made on-the-spot sketches of these scenes, then painted them back at the studio. *At the Opéra* was probably exhibited in Boston in 1878, making it the first work by Cassatt seen in her native country showing the influence of Impressionism.

In the fall of 1877, Cassatt's parents and her sister, Lydia, came to live with her. Lydia soon became her favorite model, and the artist began to paint more works than ever before.

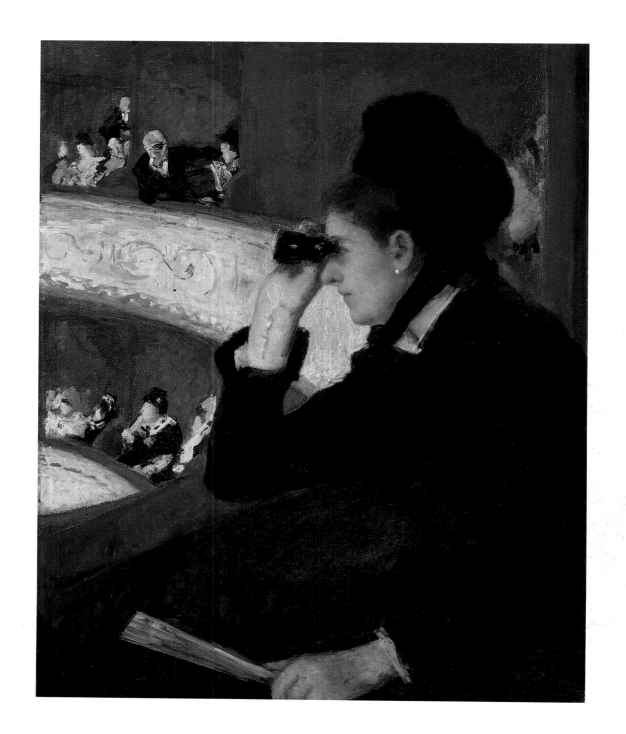

Lydia Crocheting in the Garden at Marly

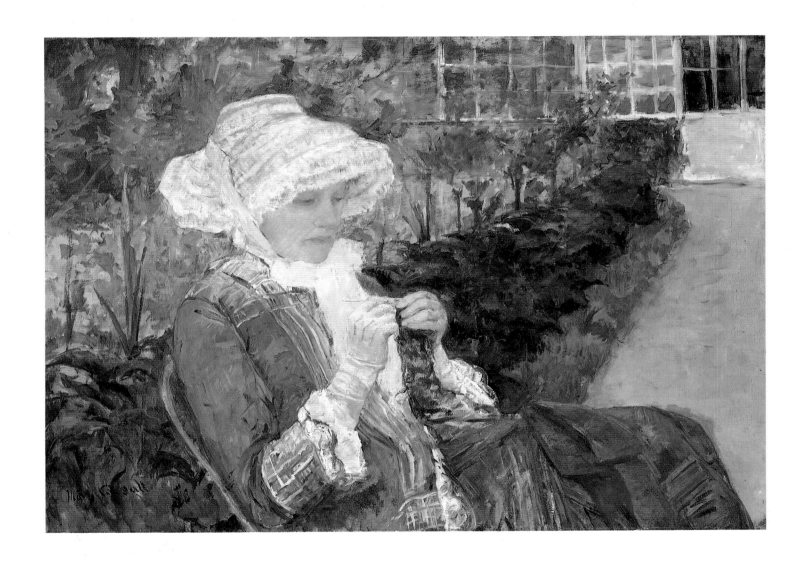

Delicate patterns of white fabric isolate the face and hands of Cassatt's older sister, Lydia. A sun bonnet covers her head, a ruffled bow falls from under her chin, and cuffs emerge from her coat sleeves. Stark white is softened by tinges of yellow and blue. As Lydia concentrates on her crocheting, her pale face suggests inner discomfort. In contrast, the verdant scene around her is painted in dark, rich colors. The wide satin ribbon on the sitter's lap links her to the deep red shrubs that form a diagonal band behind her. Slanting from the bottom left corner almost to the top right corner of the painting, the vibrant green leaves speed the eye backward to a small house decorated with a white trellis. Cassatt used thin washes of oil paint to achieve the soft effect of greenery and the red flowers behind the model's bonnet. Like an out-of-focus background in a photograph, it provides atmosphere while blurring details.

Garden paths lie flat, yet Cassatt made this one seem nearly as vertical as the wall of the house. By making the wine-red, green, and buff-colored diagonal bands of the leaves, grass, and path rise up, Cassatt balanced the side of the painting occupied by Lydia.

THE CUP OF TEA

Lydia was also Cassatt's model for this scene of everyday life. To enliven the painting, Cassatt views her subject from above and close up, cropping Lydia's legs. Loose, colorful brushstrokes also give the picture energy.

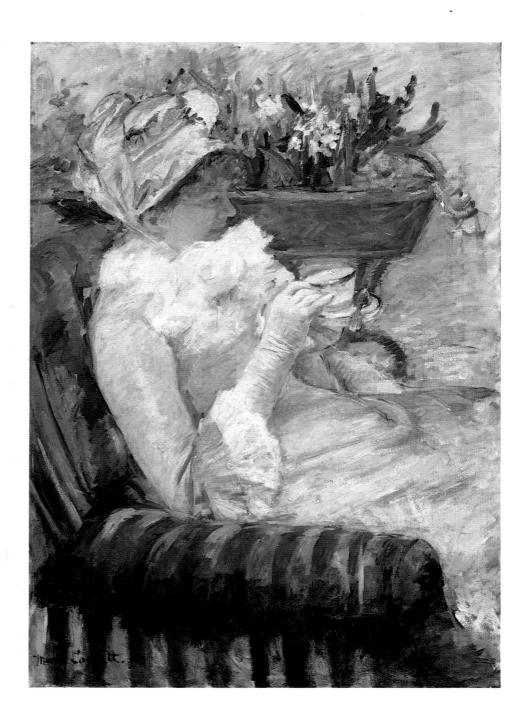

The Cassatts enjoyed this summer retreat in the country town of Marly-le-Roi. Their vacation villa, next door to Manet's, was just a short train ride from Paris. In the summer, Cassatt often painted out of doors, though she usually finished her canvases in her Paris studio.

By now, Cassatt no longer had ambitions to show her paintings at the Salon, preferring to exhibit them with the Impressionists and in America. *Lydia Crocheting in the Garden at Marly* was shown in the sixth Impressionist exhibition in 1881.

Throughout her career, Cassatt found subjects in her family. She pictured them doing everyday activities, such as reading and sipping tea. In this way, these images function not only as portraits, but also as modern paintings of real life in the Impressionist manner.

LADY AT THE TEA TABLE

Here Cassatt again combines an Impressionist scene of modern life with a portrait. She shows her mother's cousin sitting before the tea table.

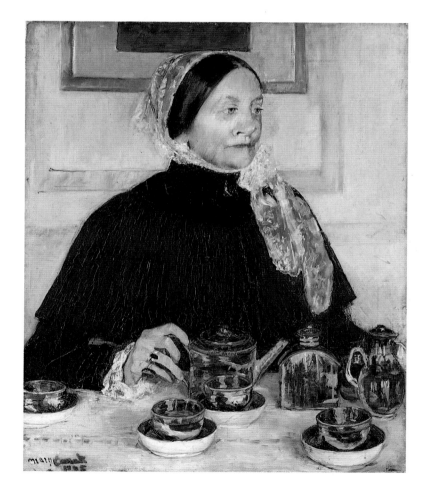

21

Five O'Clock Tea

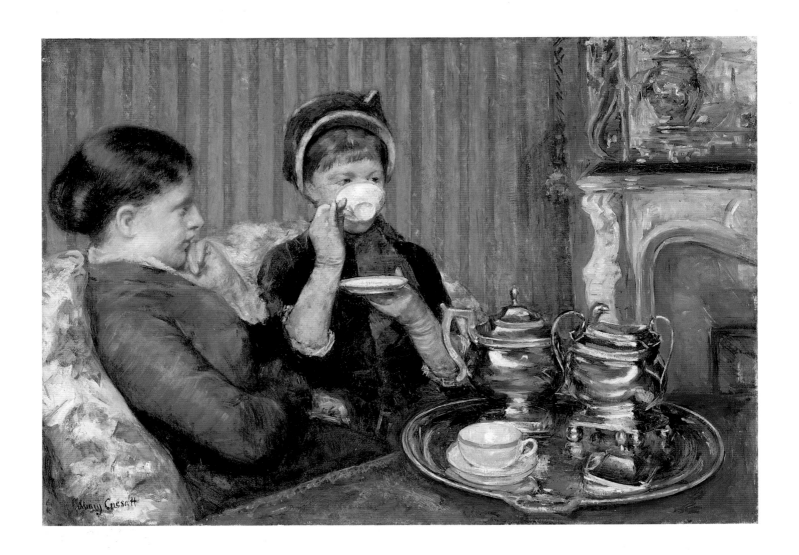

Lydia sits pensively as her guest finishes a cup of tea. The shape of the cup's silvery-gray rim is echoed in the edge of the woman's bonnet. These broken circles are part of a repeated design of round and oval shapes that enliven the painting. Others can be found in the tray and the objects on it, and in the ginger jar on the mantel. In the background, the mirror frame and the carved marble fireplace under it curve with flowing arcs that link them to the tea service. Even the back and arms of the small couch are rounded.

A Balance of Contrasts

For balance, Cassatt set these familiar rounded forms against a background of vertical lines. The edge of the table, the mirror and mantel moldings, the wallpaper's stripes, and the white saucer in the guest's hand create an impression of equilibrium. Contrasting textures balance each other, too. The lively sheen of the silver contrasts with the somber clothes of the women. Although the room is filled with beautiful and elaborate objects, the women are dressed plainly.

The women are seated very close to each other. Cassatt uses the red diagonal of the table to hide their lower bodies, so the viewer cannot see whether or not their knees bump. The deep red of the table is echoed in the red stripes of the wallpaper, focusing attention on the women's faces, which reveal that the two sitters are absorbed in their own thoughts. What seems at first to be a candid glimpse into everyday life is actually a very carefully constructed scene.

Cassatt shows her skill in painting different textures and materials. The fireplace was first painted in lavender-gray, then embellished with white. Densely packed colors imitate the carved edge of the fireplace frame, and loose strokes indicate the front of the fireplace and the edge of the mantel. The mirror frame is similarly constructed, first painted with brown and then adorned with strokes of yellow, suggesting gilding. Bright touches of white, blue, and rose make the tea vessels look like silver.

The tea set was a Cassatt family heirloom. Afternoon tea was a ritual of the leisured class, and Cassatt painted several tea scenes. But what interested her most was not the actual drinking of tea, but describing how people react to their surroundings and each other.

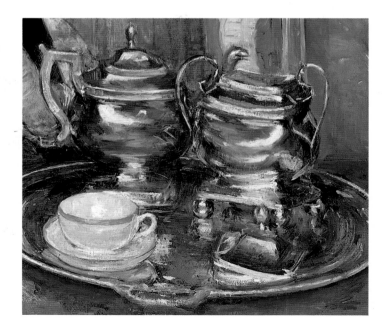

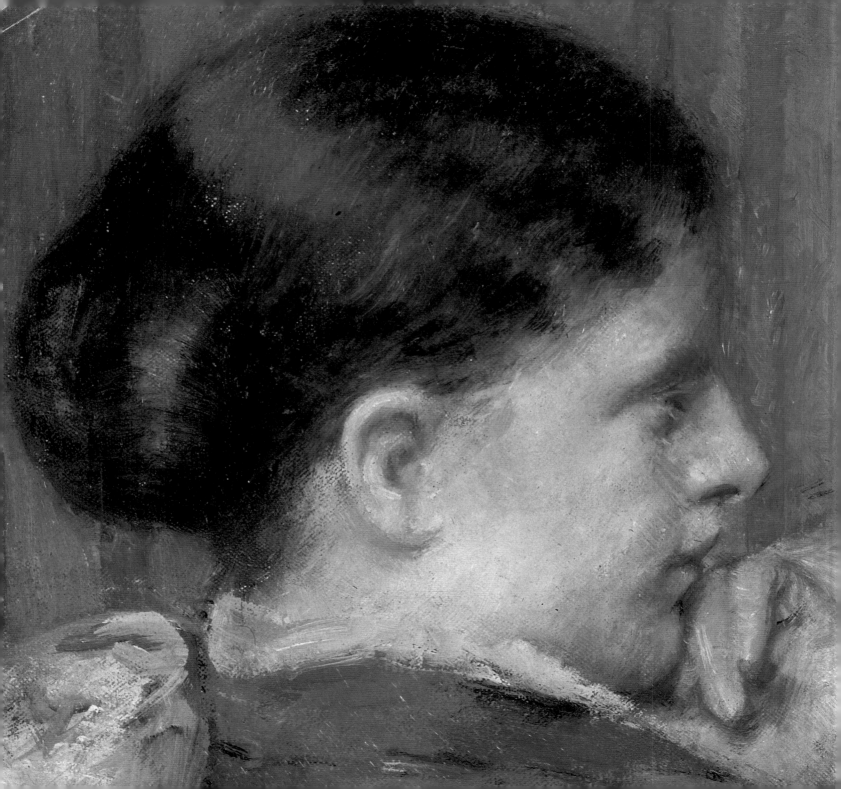

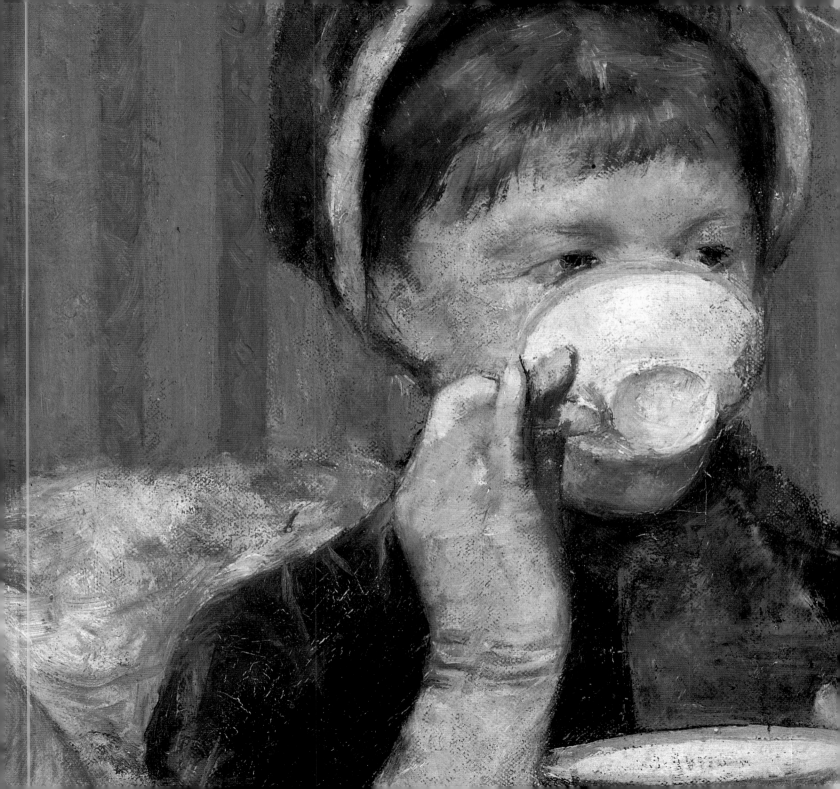

Reading Le Figaro

A few years after Cassatt's mother came to France, the artist painted her settled comfortably in French culture reading *Le Figaro*, the popular Paris newspaper. The sharply folded newspaper looks white at first, but Cassatt used a number of shades to create it. Painted not just with white but with black, brown, and pink, the newspaper reflects the colors of its surroundings. Bright white is confined to the edges and creases of the folded sheets to make them stand out. Inky black newsprint is indicated with shades of gray and pink, giving only an impression of the newspaper's name. Cassatt indicates just enough of the letters to let the title, however obscured, be unmistakable: LE FI.

Mrs. Cassatt's white dress billows out across the bottom of the canvas. Like the newspaper, it is composed of several colors, including white, gray, pink, and cream. By placing touches of dark gray beside the bright

white collar and cuffs, Cassatt makes the frilly lace trim of the dress stand out.

The newspaper engages Mrs. Cassatt's complete attention. The flesh tones of her head and hands, the only warm colors in the painting, draw attention to it, too. The darkest color in the painting, the black of her eyeglasses, indicates her focused concentration. The vertical frame of the mirror points down to the sharp fold of the newspaper, and the gleam of Mrs. Cassatt's wedding band picks up the golden color of the frame. The reflection in the mirror makes the composition seem deeper.

Symphonies in White

The Cassatt family knew James Whistler, an outstanding American artist who lived in Europe. Titles of his paintings often combined musical terms with colors, such as *Symphony in White* and *Nocturne in Black and Gold.* Whistler's most famous work is commonly referred to as "Whistler's Mother," but is actually titled *Arrangement in Grey and Black, No. 1: Portrait of the Artist's Mother.* Cassatt may have been thinking of this work when she created so many shades of white in this picture of her mother reading a newspaper. We may think of *Reading Le Figaro* not only as a portrait of Cassatt's mother, but also as *Arrangement in White and Gold.*

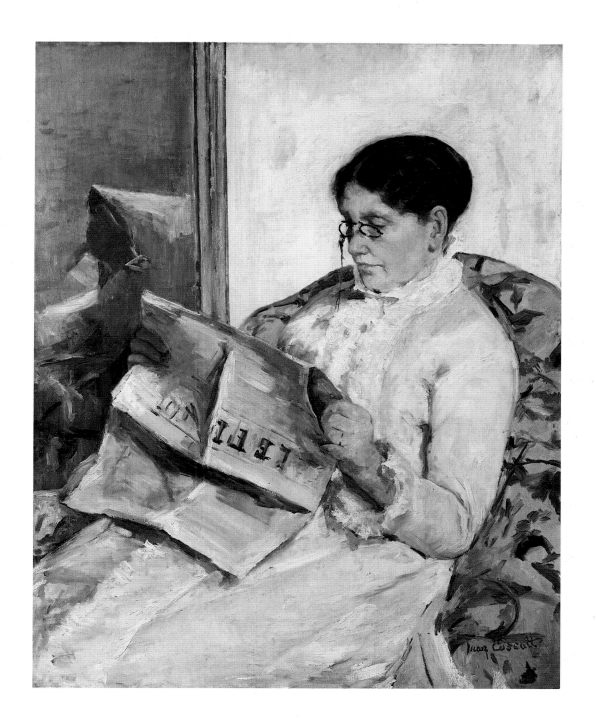

Children Playing on the Beach

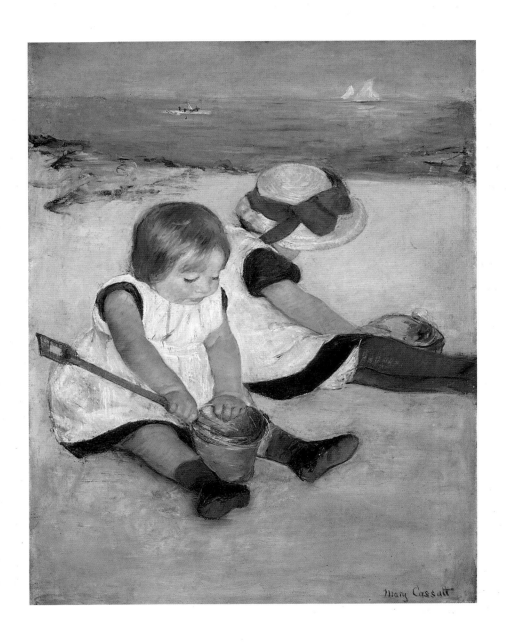

Like the other Impressionist painters, Cassatt captured scenes of everyday life at the beach. Here she shows two little girls playing in the sand, concentrating on their buckets.

Cassatt's viewpoint is from above, creating the effect that the viewer is standing on the beach looking down at the children. To make everything visible, Cassatt had to look not only down, but also up and out to the sea, the boats, and the distant sky. She rearranged what she actually saw, and made all the different elements form part of a single scene. The sweep of rocks and sand that divides the water from the beach is interrupted by a straw hat, carefully placed there by the artist. A maroon-colored ribbon around it marks its importance, for its yellow crown links the foreground and the background.

The artist focused so closely on the children that the feet of the girl on the right extend beyond the picture's edge. This cropping heightens the impression that the artist created her work on the spot.

Warm Children by the Cool Sea

Cassatt simplified the background of her painting to focus on the children. They do not even cast any shadows on the ground! The colors of the background, primarily blue, white, and buff, are used for the children as well. But while the background is made up of flat, horizontal bands of color, the children and their buckets are formed of circles and other rounded shapes. The background colors are cool, but Cassatt emphasizes

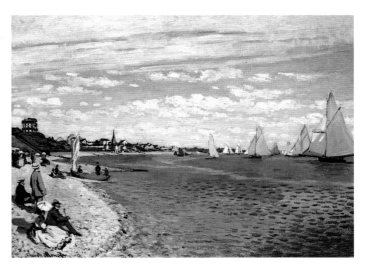

Claude Monet
REGATTA AT SAINTE-ADRESSE

In 1867, Claude Monet, the most famous Impressionist, captured this sun-filled day on the beach by showing mostly sea and sky. He did not focus on the people in the composition.

the warmth of the children in their rosy flesh and the brightness of their clothes.

The children in this painting and the beach where they play have not been identified. In 1884, Cassatt took her mother to coastal resorts in Spain and France, hoping that her health would improve. At about this time, she painted portraits of her young nephew, and letters from her brother say that she did not make the boy pose for very long periods of time. The girls on the beach were probably treated the same way. It is likely that Cassatt encountered them at one of the places where she and her mother stayed.

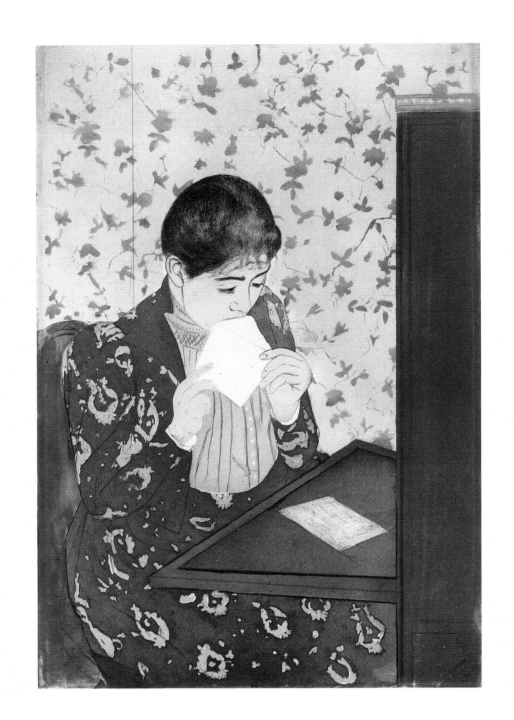

The Letter

This picture looks like a delicate drawing or watercolor, with its thin, graceful lines and transparent colors. But in fact, it is neither. It is the result of a combination of three kinds of printing techniques: drypoint, etching, and aquatint. To create this image, Cassatt engraved her outlines into a copper plate with a pencil-shaped steel tool. The tiny bits of metal that collect on either side of the engraved lines enrich them when printed. This is drypoint, used throughout the face, ear, and right hand. In etching, lines are drawn through resin, which coats the metal plate. An acid bath eats into the lines, while the rest of the plate is protected by the resin. Cassatt used soft-ground etching, in which materials like cloth or paper are pressed into the resin to soften the lines. The woman's hair was given its special character with soft-ground etching. To create fields of color, Cassatt used aquatint, an etching technique that uses tiny particles of resin over large areas of the plate. When printed, the areas of color look transparent. Cassatt hired a printer to help her produce multiple versions of this and other images.

In *The Letter,* some areas were not inked. The cuffs at the woman's wrists, the envelope, and the letter were carefully masked by the artist so that they would remain white. Because the two pieces of paper are the brightest parts of the design, they stand out. The envelope forms the center of the composition. Its unusual geometric shape is echoed in the desktop.

Subtle Variations

The finished prints are all of the same design, but each has slight variations. The pale vertical marks down the dark side of the desk in this image are an example. They were left by a cloth that wiped off excess brown ink. The artist confessed that thirteen trial proofs, or test printings, were necessary to correct and perfect

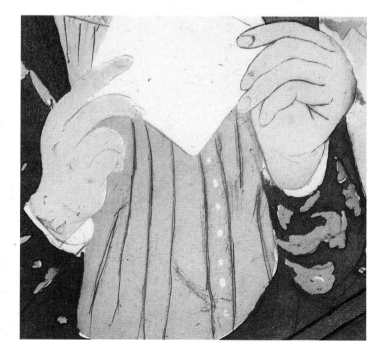

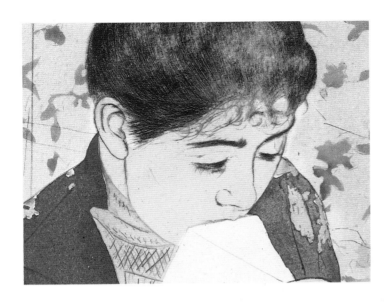

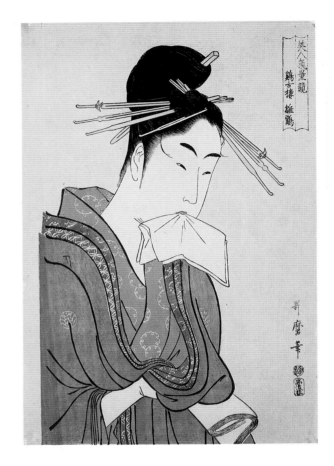

Kitagawa Utamaro
FACES OF BEAUTIES: HINAZURU OF THE KEIZETSURO

each print. The work was arduous, even with the help of the professional printer who operated the press, but it had one great advantage over drawing and painting: The image could be reproduced many times over.

In 1890, shortly before this print was made, an exhibition of more than seven hundred Japanese prints was held in Paris. Cassatt wrote about it to her artist friend Berthe Morisot: "You who want to make color prints, you couldn't dream of anything more beautiful. I dream of it and don't think of anything else but color on copper. . . . I went and was in ecstasy." Cassatt also collected Japanese prints, and *The Letter* shows her complete absorption in them: She uses tilted perspective for the desktop, graceful, continuous lines, and clear, flat areas of color. Even the subject is found in Japanese prints.

Cassatt's inspiration was the work of Kitagawa Utamaro, an artist who had lived a hundred years earlier. Like Cassatt, Utamaro enjoyed making images of women. Like all Japanese prints of the time, his designs were printed from carved blocks of wood, one block for each color.

The Letter is patterned after a portrait by Utamaro of a Japanese woman named Hinazuru. Cassatt carefully selected elements from Utamaro's print. She created a coiffure like Hinazuru's, bringing her subject's hair above the neck and ears. She also borrowed the angle of the Japanese woman's head and her downcast eyes. Hinazuru puts a white handkerchief in her mouth, traditionally what Japanese women did to avoid sighing when in love. Cassatt, instead, shows the woman sealing an envelope, perhaps containing a love letter. In doing so, she discreetly transforms the handkerchief gesture into a more European motif.

Cassatt's first solo exhibition was held in Paris in 1891. Demonstrating the importance of printmaking, it featured ten color prints, including *The Letter*, along with two paintings and two pastels. Her prints remain among this artist's most popular works.

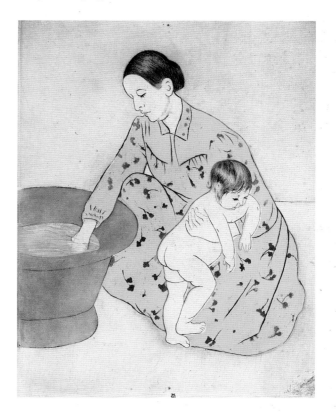

Kitagawa Utamaro
MIDNIGHT: MOTHER AND SLEEPY CHILD

THE BATH

33

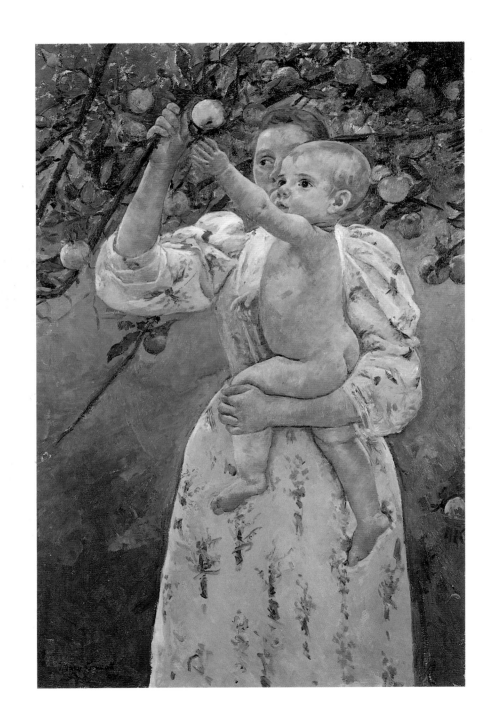

Baby Reaching for an Apple

In this painting, Cassatt concentrates the most interesting parts of the composition at the top of her canvas. The dense canopy of branches, leaves, and fruit shelters the heads and arms of the mother and child. A single branch sags downward, linking the upper section of the painting with the lower part.

The mother supports the baby, bending a branch to let the child reach out and pick a piece of fruit. The baby focuses on the apple, determined in the task. The glances of both figures direct our eyes to the red and green apple. The baby's reaching arm and the bent arm of the mother form a triangle, which also points to the fruit. The woman and child both look intently at the apple, and it is their eyes and hands that tell the story.

Throughout the picture, Cassatt used variations of pink and green. The mother's dress is a pink slightly brighter than the baby's soft skin. The dress and the rosy skin tones of the baby's flesh stand out against the apple-green lawn behind them, which serves as a flat backdrop. The apple tree's foliage is rendered with flecks, slashes, and dabs of green, brown, and pink, creating the effect of leaves moving in the breeze and dappled sunshine.

Modern Woman

This painting relates to a large mural that Cassatt had been asked to paint for the Women's Building of the World's Columbian Exposition of 1893, held in Chicago. Her subject was "Modern

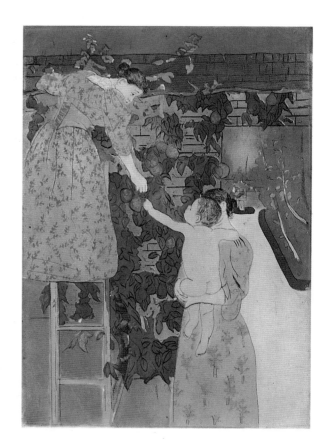

GATHERING FRUIT

35

Woman," and its centerpiece was entitled "Young Women Plucking the Fruits of Knowledge and Science." Cassatt chose to illustrate an everyday scene of women gathering apples in an orchard and handing them to children. The semicircular space she had to fill was fifty-eight feet long, twelve feet high, and more than forty feet above the ground! Cassatt spent one long summer painting the mural in France, but she never traveled to Chicago. Because her largest figures were just under life-size, to the organizer of the Women's Building she wrote, "You will have to stretch your neck to get sight of it at all." After the Exposition, the mural was either lost or destroyed, but a number of the artist's paintings of the same period feature the picking of apples. Perhaps, like the mural, all of them are allegories.

An Occasion of Rejoicing

Cassatt made the picking of apples into what she described as an "occasion . . . of rejoicing." As the title of the mural indicates, these apples were not just ordinary fruit, but also represented knowledge. The image of the child is also symbolic, representing future generations. Cassatt's painting is serious and optimistic. It says that knowledge and science are within the grasp of every child.

Toward the end of the 1880s, Cassatt began to concentrate on the theme that would become the hallmark of her work: the mother and child. Other members of the Impressionist group also explored variations on single motifs. Degas painted ballet dancers time after time, and Claude Monet worked with several themes, including haystacks, cathedral facades, and water

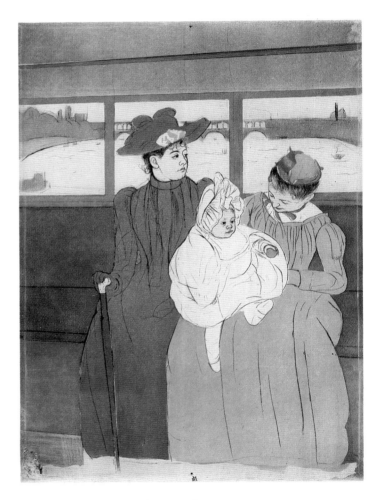

IN THE OMNIBUS

lilies. Perhaps Cassatt found her inspiration for the mother and child theme in her many nieces and nephews. Or maybe she was influenced by the painters of the Renaissance, who often depicted images of the Madonna and Child. Her goal, like her friend Degas's, was to combine principles of old master painting with themes of modern life.

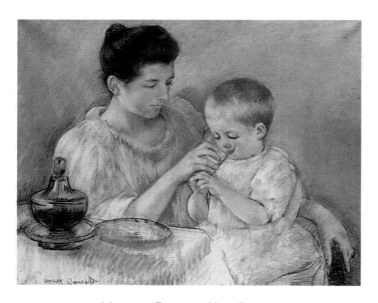

MOTHER FEEDING HER CHILD

Cassatt's paintings of maternal themes often focus on the positions of hands, the angles of heads, and the cast of eyes that express the bond between a mother and her child.

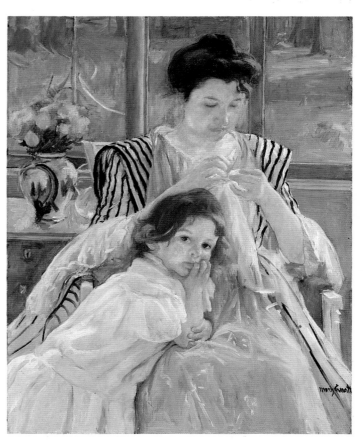

YOUNG MOTHER SEWING

A rowboat ride on a sunny day can be a peaceful activity, but Cassatt used dynamic shapes and bright colors to fill her painting with energy.

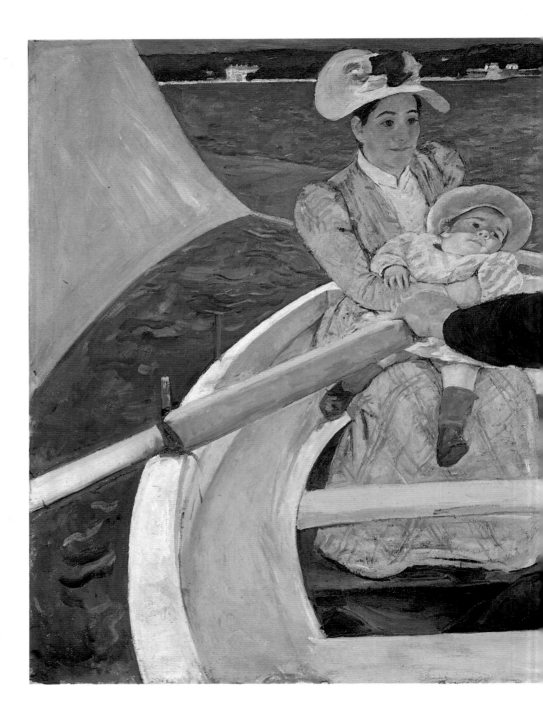

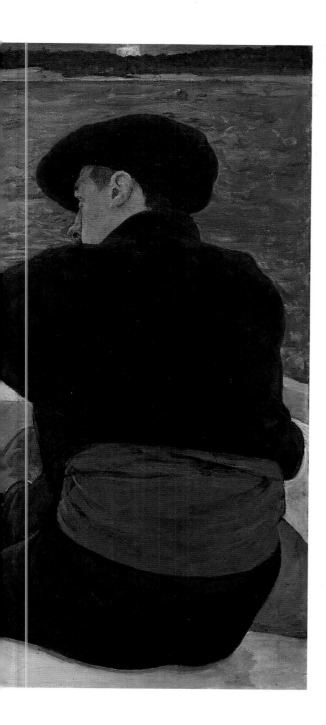

The Boating Party

Cassatt depicts this scene as if she were standing in the back of the boat behind the oarsman. It is a strategic spot as well as a pleasant one. Following the angle formed by the rower's dark sleeve and the sturdy oar in his hand, Cassatt leads the viewer to the heart of the composition: the baby, sprawled restlessly against her mother.

Engaging Gazes

Cassatt connects the people both visually and psychologically by linking the direction of their gazes. The baby's eyes and face are turned toward the oarsman, and the mother looks at him gently as well. The man, in turn, looks at the child. Although most of his face is hidden, it seems clear that he is engaging the child's attention.

Cassatt also linked the other parts of the composition. The bottom of the billowing sail forms a curve that is repeated in the white and yellow edge of the boat and in the edge of the ledge on which the woman sits. These three long, gentle arcs are at equal intervals. Other curves appear in the shoulders and waistband of the man and in the brims of the hats. The boat's yellow slats and the shoreline form strong horizontal contrasts to the curved lines. By repeating these shapes again and again, the artist integrated and balanced all the parts of the painting.

Details were of little interest to Cassatt when she painted *The Boating Party*. Instead, she concentrated on large, dynamic shapes. The dark silhouette of the man balances the white sail. The flat blue sea is tilted upward, making it a striking backdrop for the figures and the boat. Cassatt adapted the dramatic cropping, view-points, and bright colors of Japanese prints to a large-scale painting.

This painting was begun in 1893 while the artist vacationed at Antibes, a resort city on the French Riviera. Cassatt completed the painting in her Paris studio the following year. She kept it and, decades later, wrote to her art dealer, "I do not want to sell it: I have already promised it to my family."

Cassatt persuaded her good friends, Mr. and Mrs. H. O. Havemeyer, to buy Manet's 1874 painting of the same subject. But how different Manet's painting is! Manet observes his scene from a relaxed distance. His oarsman occupies the center of the picture and looks directly at us. A woman sits in the boat placidly, looking off to the right. She makes no contact with the man. Manet's boat takes up much less space than the one in Cassatt's painting, and it is neither tilted up dramatically like hers, nor brightly colored. Peaceful blue water serves as the background.

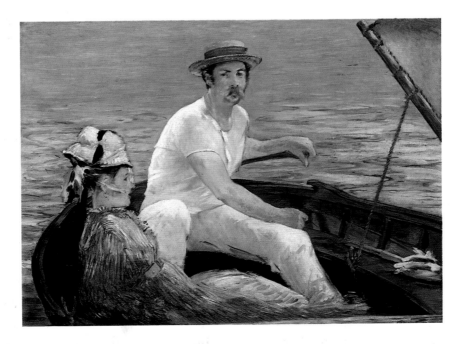

Édouard Manet
BOATING

40

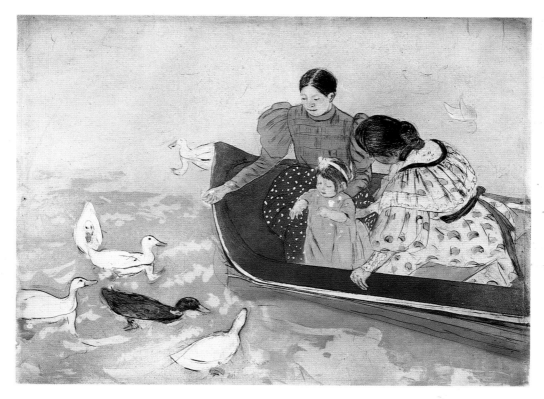

FEEDING THE DUCKS

In contrast, Cassatt's figures look at one another. Cassatt is more interested in picturing relationships between people than reflections in the water. Although she hardly ever included men in her paintings who were not her relatives, here she featured one, but with his back turned. What interested Cassatt most were women and children and their states of mind.

The generous income from the sale of her prints, pastels, and paintings let Cassatt purchase a country mansion, the Château de Beaufresne, at the village of Mesnil-Théribus in the valley of the River Oise. The nearest city was Beauvais, forty-two miles northwest of Paris. The artist would take visitors there to see the stained glass of the city's great medieval cathedral.

Cassatt's summer house had been built in the seventeenth century as a hunting lodge. Forty-five acres of grounds included lawns, huge chestnut trees, old rose bushes, a pond, and gardens. It was also a retreat for work. A young painter from Philadelphia said, "She drew that almost impossible line between her social life and her art, and never sacrificed an iota to either."

Breakfast in Bed

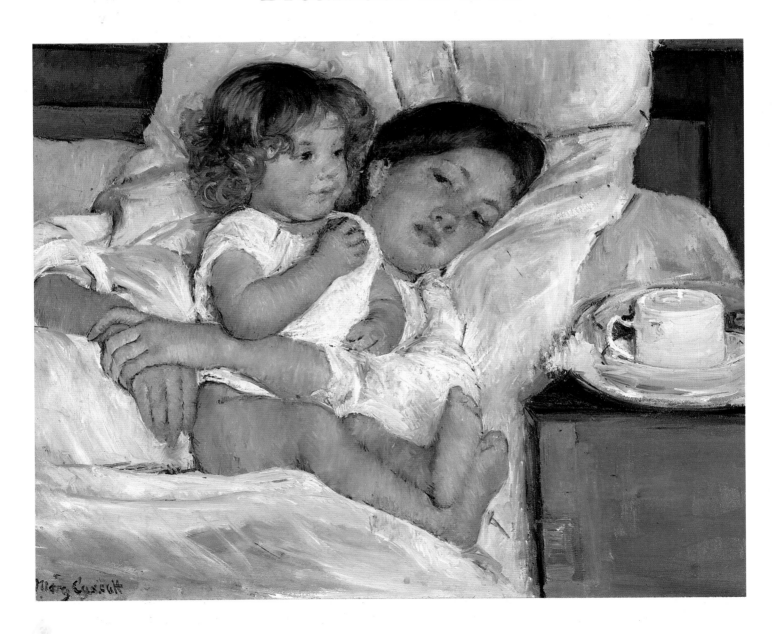

In this cozy scene, a mother and child cuddle in bed in the morning. The mother, despite her groggy look, grasps her arms firmly around her child to prevent a fall. The child holds a piece of food in one hand and looks eagerly at the plate beside the bed. The mother's eyes convey her maternal love, as does her secure embrace. By moving in close to her subject, Cassatt allows the viewer to enjoy this intimate moment.

Early Morning Atmosphere

Oval shapes tie the painting together. The white saucer echoes the shape of the child's head, and the oval tray follows the contour of the mother's face. The bedding, clothes, plate, and cup are painted in various shades of white, their shadows mixed with blue. The grayish-brown headboard and table are also cool tones. The mother and child, however, are rosy and warm shades of pink. The gold in the child's shiny blond curls is repeated in the plate's edge and the square knob at the bottom right.

Everything that is white is round, oval, or curved. The weight of the mother's head softens the square pillow. Cassatt placed grayish-green rectangles in three corners of the canvas. Their straight lines and solid shapes stabilize the composition, holding the white areas in place.

Although Cassatt typically used smooth, continuous outlines in her work, here she chose a different approach. Everything is soft. For the child's feet and legs, the artist used slashes of paint to blur the edges. She also made the separation between the plate and the bedding fuzzy. By softening things this way, Cassatt created an atmosphere of early morning that matches the mother's dreamy, drowsy expression.

Cassatt enjoyed professional success as well as suffered personal loss in the 1890s. In 1893, she had another solo exhibition in Paris. Only two years before, her show had consisted of fourteen works, but this one had ninety-eight. In 1895, the show traveled to New York. This decade also witnessed the death of her parents, her father in 1891 and her mother in 1895. Yet the artist was not alone. Her younger brother and his family came from America for a two-year stay. This brought the artist's favorite niece, Ellen Mary, under her roof.

Cassatt took outings every day, sometimes walking, but more often riding in a horse-drawn carriage. As she passed through country villages, she had her eyes open for potential models. The rosy-cheeked young women of her paintings and their robust children were often discovered this way.

Her Style Was All Her Own

In 1898, for the first time in more than twenty years, Cassatt traveled to America, where she painted portraits of family and friends. Upon her return to Europe, she spent time traveling with her friends the Havemeyers, who depended on Cassatt's advice in building their art collection. The Impressionist circle exhibited together for the last time in 1886. Cassatt was no longer close to them, and her style became all her own.

Mother and Child

A little girl sits quietly on her mother's lap and, with her help, holds a mirror. All four hands are engaged in the activity. At the same time, the mother can marvel at her daughter's concentration, for she sees her rapt face in the oval-framed glass. Behind the pair is another mirror. Three images result: the mother and child, the child's reflection in the hand mirror, and the reflection of the mother and child in the large wall mirror. Never before had Cassatt explored the mirror device so playfully.

Youth and Maturity

Cassatt needed to look at the mother and child from very high up; otherwise they would have blocked their own reflections in the mirror on the wall. The figures are surrounded by the green of the chair as well as the green of the mirror frame. The angle of the woman's left forearm corresponds to the slant of the chair back. The pleasing pattern of vertical, horizontal, and diagonal bands formed by the green mirror frame and the chair is a backdrop for the circular pattern of soft gold and rose-colored circles of the hand mirror, the heads, and the sunflower. The child is naked, but the mother is dressed in a splendid yellow gown of flowing and varied fabric, adorned with a sunflower. Cassatt contrasts the innocence of childhood and the bloom of maturity.

Typical of Cassatt's later paintings, the brushwork is loose and free, and the figures are grand in size. The background is flat, without details that detract from the mother and child. Cassatt may have chosen this sunflower gown for *Mother and Child* because the fall of its long, split sleeve anchors the mother to the invisible floor.

No matter how many times Cassatt pictured mothers and children, she found new ways to arrange the figures and relate them to each other. Even as Cassatt grew older, her pictures of mothers and children remained youthful. Finally, she lost her eyesight and had to stop making art.

Young artists who visited Cassatt marveled at her ardor and understanding of art. One said that his convictions about the importance of art grew more intense because of meeting her. She died at the Château de Beaufresne in 1926.

Cassatt's Lasting Contribution

At the time of her death, Cassatt was much better known in Europe than in America. After all, she had only visited her native land twice during the fifty years that she lived in France! One of her most lasting contributions to art,

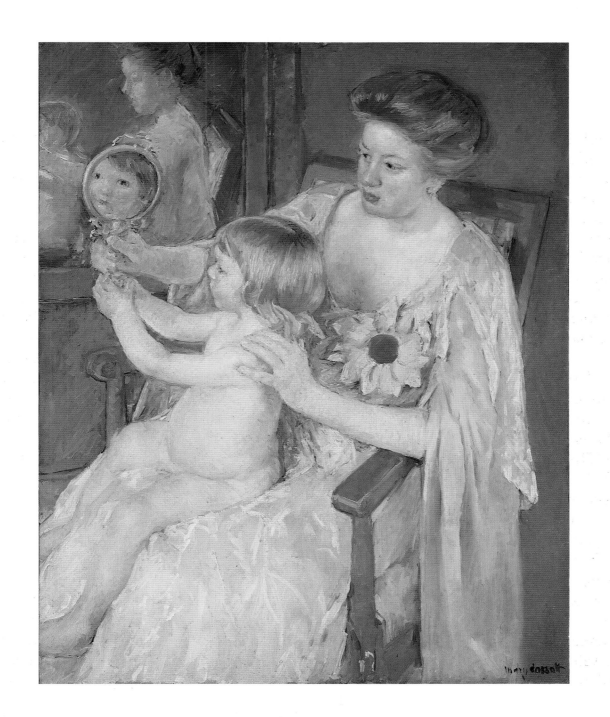

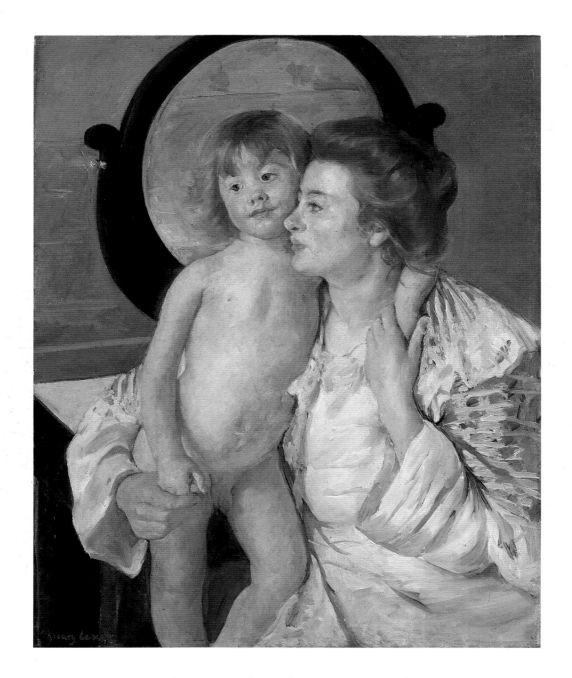

MOTHER AND CHILD (THE OVAL MIRROR)

however, was in the United States. When Cassatt was thirty years of age, she met an American woman named Louisine Waldron Elder and convinced her to buy a work of art by Degas. Miss Elder brought it home with her, making it the first Impressionist painting to reach North America.

After Miss Elder wed H. O. Havemeyer, an immensely wealthy businessman, Mary Cassatt led them both to the best French Impressionist paintings for their collection, and she also helped them buy paintings by old masters. The Havemeyers introduced the artist to other collectors, and the circle of knowledge grew. After the original owners enjoyed their private collections, most of these paintings were given to art museums in Chicago, Boston, New York, and other cities. Today, works purchased at Cassatt's urging form a treasure trove of nineteenth-century French art that rivals, in size and quality, the largest collections in Europe. Fortunately, Cassatt's friends purchased her paintings, too. They will be seen forever with the art she knew and loved best.

MARY CASSATT

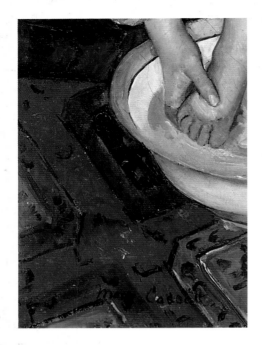

What Makes a Cassatt

Intimate moments between mothers and children are her favorite subjects.

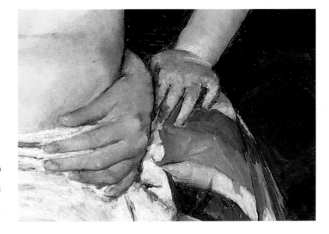

Japanese prints inspired contrasting patterns and tilted perspective.

Hands link the two figures and tell a story.

Cassatt liked to crop her subjects in unexpected ways.

Cassatt often used solid lines and clear colors.

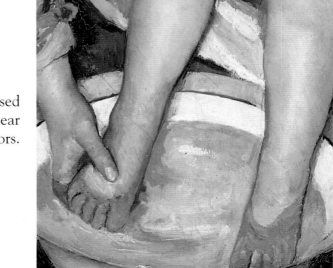